ACRYLICS

BY
R. BRADFORD JOHNSON

TRANSLUCENT TECHNIQUES FOR LANDSCAPE PAINTERS

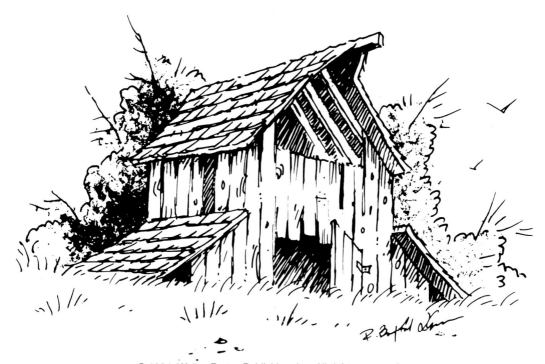

© 1984, Walter Foster Publishing, Inc. All rights reserved.
This book has been published to aid the aspiring artist. Reproduction of the work for study or finished art is permissible. Any photomechanical reproduction of the art from the publication or art drawn from the publication for commercial purposes is forbidden without written consent from the publisher, Walter Foster Publishing.

Walter Foster Publishing, Inc.
23062 La Cadena Dr., Laguna Hills, CA 92653

CONTENTS

INTRODUCTION

Though a relatively recent development, "acrylics" or polymer paints are now well established as a fine arts medium. They have the convenience of water-based paints, dry fast, and yet possess the distinct advantage of being a permanent nonwater-soluble plastic resin when dry. Extremely versatile, acrylics can be thinned with water to appear transparent or translucent without the loss of adhesion, or used in heavy impastos without the dangers of chipping or cracking. The brilliance of the colors remains virtually unchanged upon drying (or, more accurately, hardening), and the addition of acrylic varnishes add further protection and depth to the colors. This versatility extends beyond traditional painting surfaces, such as canvas or paper, to fabric, leather, wood, or any other non-oily surface.

Most of the traditional techniques for oil, casein, and watercolor can be used with acrylics, and with the addition of gels, modeling paste, and varnishes, acrylics can extend into the fields of collage and assemblage. The tough "plastic film" formed upon drying resists moisture, aging, oxidation, yellowing, cracking, and darkening common to most organic mediums.

Acrylics provide both the beginning painter and the accomplished professional with new worlds to explore, both in technique and creativity. This book, hopefully, will stimulate experimentation as well as provide instruction, so that the full potential of acrylics can be realized by each and every individual.

The sections on materials and supplies, as well as "helpful hints" and "technical tips", should be reviewed prior to attempting the actual lessons. The understanding of friskets and their use can also be of considerable value, and the age old practice of color mixing will give the artist an opportunity to *feel* the paint as well as *see* the colors prior to approaching an actual painting. This book will present opaque methods as well as the translucent use of acrylics employing many techniques of the watercolorist. With acrylics, both methods of painting can be intermixed without problems, and depending on goals and abilities, can be successful as well as pleasing to view.

It should be pointed out that not all acrylics are created equal. By this, density, viscosity, and color may vary from brand to brand. And because the formula may differ from company to company, I prefer not to intermix brands. Although it may be O.K. to apply a wet solution of one brand over the dry of another, this seems rather limiting, and the risk of accidentally intermixing two incompatible paints makes for a great inconvenience. Find a brand that satisfies your needs and stay with it, as the use of another brand may yield entirely different results.

The colors selected for my palette are discussed on the following page. The use of colors other than those I have selected will provide results that may differ greatly from the illustrations shown within. For best results, stay with the suggested colors, brushes, and accessories provided in this book for the lessons shown, though other paintings might well be handled with a variety of other colors and tools, and such experimentation is encouraged.

A basic palette placement is also presented on page 7.

As mentioned earlier, the first exercise would be to practice a conventional color wheel or chart so that the mixtures will become familiar to you. This will also afford the opportunity to *get the feel* for the paint and brushes, as well as the watercolor board support.

THE COLORS

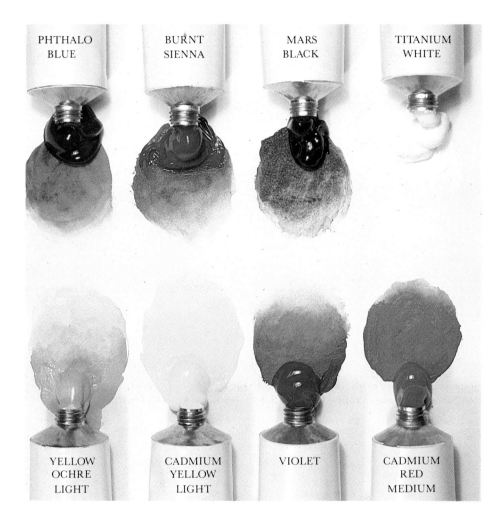

The colors shown above provide a basic and simple palette. It is necessary to have the correct colors as shown above for the lessons in this book. I devised this palette for my own use some 15 years before compiling this book, and it has served me faithfully. It may differ from the palette you may now be using, but experimentation with the colors will give you the familiarity and comfort to complete the lessons successfully. The colors shown above will give you the versatility to mix almost all the colors you will ever need.

THE BRUSHES

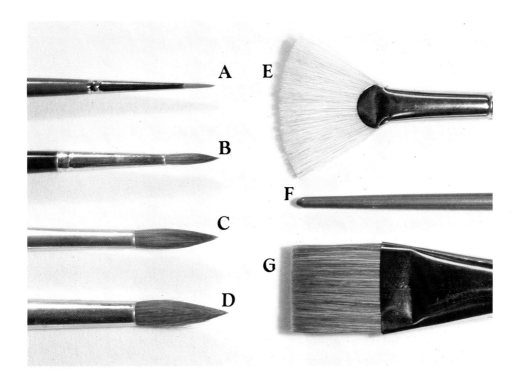

My preference for this medium, and especially for the board support, is a sturdy set of short handled sable (or sabeline) round brushes. Select a moderate priced brush that will hold up well (avoid soft brushes, especially camel hair or nylon bristle). Use the sizes shown above (pictured actual size), as numbers may vary from brand to brand, etc. I prefer a 1½″ fan brush, white bristle is fine; for my water brush, a 1″ ox-hair or nylon bristle is less costly than a sable and will do nicely in most cases. For a scratching or scoring tool, I prefer wood or plastic, as metal tends to tear the paper and often leaves pencil-like marks on the surface.

ADDITIONAL SUPPLIES

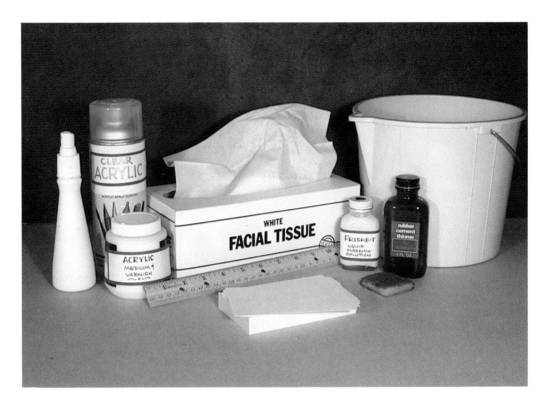

Naturally we can't paint in a water-based medium without a supply of water. Since water is both cheap and plentiful in most areas, a large bucket, or two good sized containers is desirable. A fine mist sprayer like the one shown above (a 4 oz. pump hair spray bottle) is a must (avoid trigger type sprayers). Plain white facial tissues are needed for both painting and brush care, and the tissue is certainly easier on brushes than paper towels. A bottle of *Frisket* or liquid masking solution, sold under a variety of brand names, is a must; a bottle of rubber-cement thinner is also handy for brush cleaning in the event the frisket dries. Also handy is a rubber-cement pick-up, used for both pencil erasing and frisket removal. A 12″ wooden or non-flexible ruler is also required. A glass or plastic palette is best (paper palettes tend to allow the paints to dry out quickly).

The Support

Though canvas may do nicely for impasto painting, for the lessons herein, it is recommended that you use a cold pressed watercolor paper pre-mounted on a triple weight board. There are a variety of brands, types, and sizes of boards available at most art supply stores, and heavy-weight illustration board can be used in a pinch, but the best results will be obtained if you stick with a 100% rag paper mounted on a heavy-weight board! The lessons shown in this book were completed on boards 12″ ×16″ and 14″ ×18″ inches in size.

THE PALETTE

There seems to be a difference of opinion with acrylic artists as to what makes the best palette. I personally do not care for the paper or disposable palettes. Their ability to breathe seems to dry my paints out all too soon, and laying a wet paper towel down first seems to give my pigment some strange textures when the towel begins to break up. My favorite palettes are plexiglass or plastic (white if available), and porcelain-coated butcher trays. Some of the new "heat and serve" dinners come on plastic plates that, if large enough, are ideal (or use two or more). The plastic surface will not breathe, and thus, does not allow the paint to dry from underneath. I continually spray my palette with a light mist of water, and many of my students prefer to mix *retarder* with this water, as well as in their buckets or water containers. Either is fine. Placement of the colors is important. Shown above is my preferred placement, and I will elaborate on this by stressing the fact that I have placed the Mars Black furthest from me so that I do not accidentally pick up this darker value by mistake, thinking it is Phthalo Blue. My mixing is done in the center, and I prefer to mix with a damp brush rather than with a knife. The premoistened brush adds additional moisture to the paint, extending its working time. The knife seems to squeeze the moisture out and cut the working time. Note that I prefer not to clean the dried paint from my palette. The lumpy surface is handy for pointing up the brush (just drag the tip of the brush over the lumps, rolling it between your fingers as you move), and the pools formed in the low areas once again slow drying. If you must work with a white surface, an occasional coat of gesso and acrylic varnish will re-establish the clinical look.

Technical Tips

The lesson illustrations in this book show the progressive stages of the paintings, but just as important are the techniques for achieving these results. How the brush is held, how the tissue and ruler come into play, the directions of the strokes, and a number of other technical tips that aid in the successful end result are covered below and on the next three pages. These are techniques you may wish to employ, but they are not the only methods available to the creative and resourceful artist. Other equipment, such as sponges and knives, as well as other types of brushes are also available to aid in creating these and other "illusions". But whatever you choose, practice is the key, for these must become comfortable and natural methods to be used successfully.

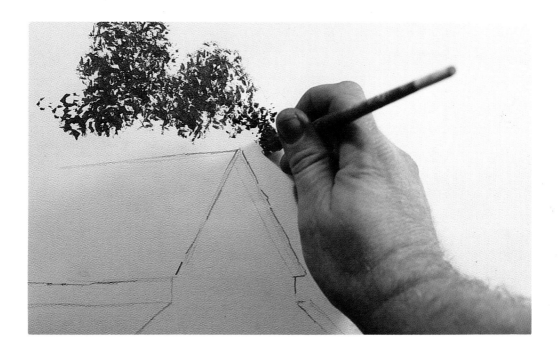

The *Stippling* Technique

This is a somewhat abusive technique for brushes, and it is best to select an older brush if possible, still using a round sable about the size of D pictured on page 5. Hold the brush almost vertical, both when applying the paint and when loading the brush. Drive the brush down hard on a neutral surface first, to "break it up", then continue to the painting, using the same downward stroke for the paint application. The viscosity of the paint is important, as it will determine the success of this technique. Not too dry, not too wet. It is best to test it on scrap paper first. Try to leave some white spots or areas, then stipple a second lighter "wash" over these to enhance the foliage illusion. Controlling the depth of the stroke will also determine the results. Don't drive down too hard on the painting. Allow the tip of the brush to dance over the board, and don't overload the brush with too much paint.

THE *WET-INTO-WET* TECHNIQUE

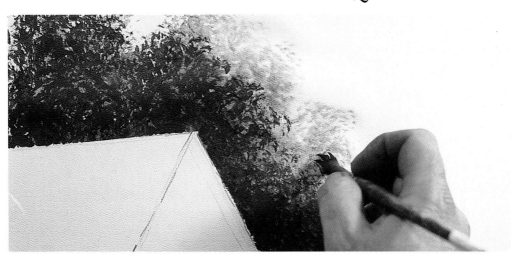

When a softer look is desired, use this technique. Shown above is the stipple technique expanded past the original perimeter to extend the depth in the foliage. When working with any large area, especially if any kind of blending is desired, it is always advisable to paint wet-into-wet. This will give you more control, longer working time, and a smoother finished look. Moving paint from a dry area into a wet area will also give your edges a softer look. And a wet sky is almost always a must.

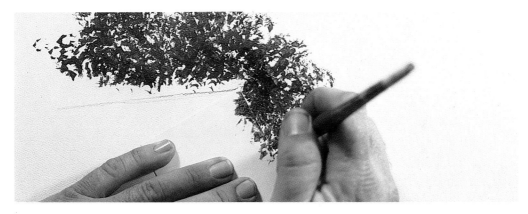

THE *CUTTING* TECHNIQUE

Sometimes the artist is faced with painting a hard edge, and although the use of friskets (liquid masking solutions) is discussed on page 12, there is sometimes an easier and less time consuming way to achieve this same end. One method is to use a 3″ × 5″ index card with the edge laid along the line you wish to protect from paint. A word of caution; avoid placing the card on wet paint, and don't drag it when you lift it off the painting. Lift it gently at the corner for removal when the "cutting" is completed, and be especially careful of "wet" solutions, which can sometimes run under the card. Shown above is a roof edge being "cut" during a foliage stipple.

THE *SCRATCH STROKE*

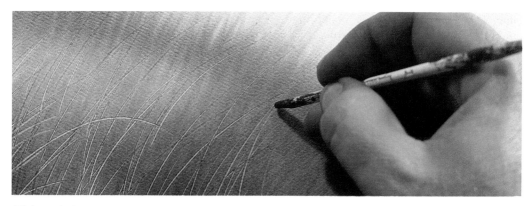

This technique can only be used with freshly applied paint that is still "wet". Use the pointed back end of a brush handle, a sharpened wooden dowel, or some similar "scribe" like tool (see page 5). You must work very rapidly, "stroking" from the bottom up. Overlap some of the strokes, and use enough pressure to remove the paint. You may find at first the strokes will appear dark, as the wet paint rushes to flow into the scuffed surface, much the same way as a blotter, but as the paint begins to set up, the scratch strokes will appear lighter. Stop when the paint can no longer be removed by scratching.

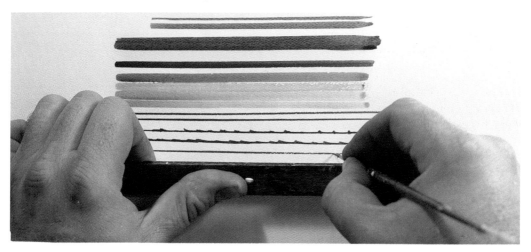

USING THE RULER AS A GUIDE

I find the 12″ ruler to be a very handy tool in painting, and for that reason I have included an explanation of its use. As shown above, hold it in such a manner that your fingers are aligned on the back surface, with your thumb pressed against the front, ruler resting along with the heel of your hand and your knuckles on the support (be sure the surface is dry first). The ruler should be tilted toward you at the top, at approximately 45°. Use the edge of the ruler as a support and guide for the ferrule of the brush (avoid touching the bristles to the ruler). For a jagged, or varied line, such as the shingles shown above, vary the pressure in a back and forth motion as you move from one side to the other.

CREATING TEXTURES

Often the artist desires to *suggest* an illusion, rather than literally depict it through precise illustration. One such area is that of textures. Rocks, wood, earth and sand, and even fabric all can be presented with less than a flat look. In the arsenal of painting tools available to the artist are such common items as facial tissue, paper towels, fabric, sponges, cardboard, and wood. A word of caution, though. Sometimes it is easy to get carried away with too many gimmicks. Experiment with some, adapt those that you like, and discard the rest. Work with those you have selected, and make them a comfortable part of your painting skills.

DABBING WITH TISSUE can create numerous illusions and effects. It can be used to create texture in foliage, backgrounds, roofs, siding, and numerous areas throughout a painting. First wad the tissue into a tight ball, then allow it to expand slightly. Tap, rather than wipe, using a light touch. Pressing too hard will give less texture than a lighter touch. Dabbing should be done very quickly, soon after the paint application, and before it has had a chance to set up. It is best to work with very *wet* solutions, as sufficient water is needed to enable the paint to lift. As with all techniques, experimentation and experience are the key words. Practice does make for perfection.

PAINTING WITH A WET SPONGE is also a popular method of creating interesting textures. Use a small (about 2″) natural sponge, and wet it first, wring it out, and then *load* it with paint. Now dab the areas you wish to texture. For smaller areas you may wish to surround the area with frisket.

DABBING WITH A DRY SPONGE is also effective for texturing. Once again, premoisten the sponge, and wring it out. Then dab lightly into freshly painted areas, being careful to turn it occasionally so as not to "print" color back onto other unprotected areas.

FRISKETS...LIQUID MASKING SOLUTIONS

FRISKETS are liquid solutions designed to be painted over, and then removed at a later time. The advantage of this is obvious. Instead of "cutting" around smaller objects in working large areas, you simply cover them with a temporary protective coating, paint the entire area, and then, upon drying, remove the frisket and fill in the now clean areas. Thus, your brushwork in larger areas remains consistant, and the smaller objects and areas can be detailed accordingly.

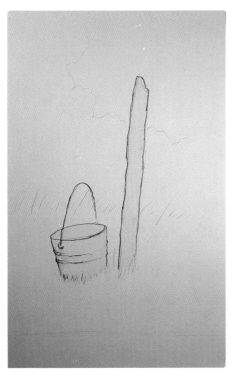

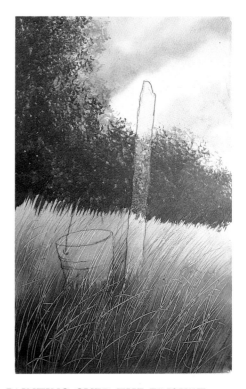

Shown above is the drawing. As we have done throughout this book, the yellow areas represent those areas covered in Frisket. Always check your solution to be sure it is thin enough to flow evenly. Water can be added to the wet solution for thinning; and always stir rather than shake to mix and avoid bubbles. Use a brush that can be discarded if you are unable to clean it well enough for painting use (a mild solution of soap and water is best if used right away; for removal of dried frisket, rubber cement thinner often works).

PAINTING OVER THE FRISKET once it has dried, is accomplished in much the same manner as if the frisket were not there (heavy opaques may make the frisket difficult to remove; thus it is best to frisket those areas in which the wash or transluscent approach is being used, rather than with opaque techniques.) Shown above is the large foreground grass area being applied as a wash, and then scratched with the handle of the brush. Most friskets will resist light scratch strokes, but use caution anyway. Note that the bucket and post are painted over as if they did not exist. Don't try to paint around them. Wait for the painting to dry before attempting to remove the frisket.

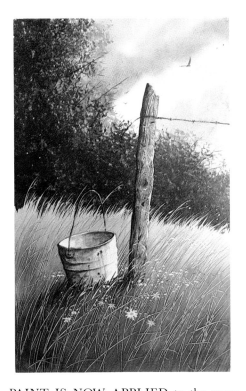

REMOVAL OF THE FRISKET MASK is done only after the painting has dried thoroughly. The frisket material is a rubber-like film when dry, and is easily removed with a rubber cement *pick-up*. The material in the *pick-up* resembles the rubber found in crepe-soled shoes. I also recommend this *pick-up* for any erasure work on watercolor paper or board, as it tends to do less damage to the surface. A rough or scuffed surface tends to absorb paint very rapidly, like a blotter, often creating a darker area of paint. Once the mask is removed, you may then proceed with the painting.

PAINT IS NOW APPLIED to the areas originally protected by the frisket mask. Here the bucket and fence post are modeled as round cylindrical objects, with the light source at the right. The bucket is done with a wash solution of Phthalo Blue and Mars Black, working the darker left side into a pre-dampened right side, creating a soft and subtle transition. A slightly darker color may now be applied to the left side and right interior. Remember to make the opening at the top eliptical, not round. You can use brush A to detail the bucket rim, holes, and wire handle, using the same color and subtle touches of white, or white mixed with the color solution. Rust can be added with Burnt Sienna or a mixture of Burnt Sienna and Mars Black. These colors are also used to mix the woodtones for the fence post. Model the post the same way, but dab for texture with a wadded facial tissue. Add grain and detail once again with the small brush. A final touch is to bring some of the grass strokes and flowers over the bottom edge of the bucket and post to ''place'' them in the ground.

Helpful Hints

USE PLENTY OF WATER...when attempting wash or watercolor techniques. I find that most beginners, and many experienced "opaque" painters, have a difficult time adjusting to the use of the water for value control. More water for lighter values! Test your colors on a neutral scrap board (it's best to stick with scraps of the same material as your support whenever possible—or use your 3×5 index cards). Water can first be applied to the support with a brush, sponge, or mist sprayer just before your paint application for wet-into-wet, the soft look, or just for time management or drying control.

THE MIST SPRAYER...can be used during the painting to extend drying time. But a word of caution; don't hold your sprayer too close or spray too much water on the painting, as it may run, creating possibly a worse disaster than the one you were attempting to prevent. Select a sprayer that truly does give a *fine mist*, not one that acts more like a squirt-gun.

WHEN APPLYING WASHES...start at the top and work down, allowing gravity to feed a bead of the wash to the bottom edge, then work this across and down, repeating as needed for completion of an area. Whenever possible, work your wash over a pre-dampened area. You will gain drying time and control.

WET-INTO-WET...WHERE AND WHEN? It is best to decide when the soft look of this technique will be beneficial prior to using it. You may wish parts of the painting to have hard edges, or a crisp clarity. The wet-into-wet technique can then be used in contrast to create depth, the soft illusion of fog or mist, or just when you want control of the drying for blending in large areas. But plan your usage...decide in advance where you want softness, and where you wish crisp lines and hard edges. Use this contrast to compliment each other.

RETARDERS...can be used to slow drying time of acrylic paints. The rapid drying time of acrylic is considered to be an advantage, but if you find that it is drying too fast, mix a little retarder into your paint, or add some to your water (including your mist sprayer).

CLEAN-UP...in most cases can be accomplished with a mild soap and water. If you prefer a clean palette and you did not use a disposable palette, wash off any wet paint, then place the palette into a tub of luke warm water (yes, you can use your sink if it is available...and large enough) and allow it to soak for about an hour. Most of the dried paint will then lift off, or can be peeled away. Avoid scraping the surface with a knife or razor blade if possible. Dried acrylic paint can sometimes be removed with denatured alcohol, or lacquer thinner. But don't use this substance on surfaces that might be damaged or stained, such as fabrics and some plastics. For brushes with dried-in paint, lacquer thinner can be used to clean them. Soak first, then rinse in mild soap and water. Place these in a can or jar, inverted with the bristles up, and allow to dry (shape first if possible—try wetting the brush, then shaking it to a point). Avoid, if possible, skin contact of paints, lacquer thinner, and other cleaning solvents. It is always best to wear older clothing when you paint, as it is conceivable that even the most cautious and careful painter will have the inevitable and unavoidable accidents (trust me).

An Explanation Of The Lesson Plan

Rather than repeat many of the same steps found in each progressive lesson, only the new areas are illustrated in depth, thus affording you with an opportunity to explore a greater number of compositions than if all the material, methods, and techniques were combined into one or two paintings. Starting with a relatively simple and basic landscape, the lessons progress through seasonal changes, additions of structures, objects, and changes of mood and lighting. Included with each new painting (or lesson) is a line drawing of the subject with a grid overlay. Various areas of the painting will be marked "repeat" (area) from lesson #1 or #2, or whichever area from the appropriate lesson is being repeated. An example of this would be the foliage, which is handled much the same from painting to painting, with maybe only subtle color or value changes. A reference to the color picture of that particular lesson will clarify these differences, subtle though they may often be. Also shown in the line drawing will be areas in yellow. These are areas you may wish to Frisket prior to beginning the painting. And many of the embellishments may not be illustrated within a particular lesson, but since most of these are handled the same, you will find that I have included all of these conveniently in the final section of this book, on pages 62 & 63. A discussion of the final finish or varnish-like protective coating is discussed on page 64, and is appropriate for all the included subjects and lessons.

THE COLOR MIXES are shown at the top of the page prior to the steps illustrated in these colors within each lesson. For best results, adhere to these colors and mixtures throughout.

THE GRID is presented so that you may accurately expand or reduce the size of your painting in relation to the line drawing shown. By simply dividing your support into the same grid (by quarters, both vertically and horizontally) you can transfer the drawing line by line, a section at a time, much more accurately. I do recommend that you do any sketching, drawing, and designing on tracing vellum first, rather than on your watercolor paper or board. The less you erase on the support, the better.

TRANSFER YOUR DRAWING to the support from tracing paper, or from your sketch book, with graphite. I prefer to graphite the back of my tracing paper with a pencil, rather than use graphite paper, many of which use wax as the adhesive for the graphite. This wax, quite often, tends to repel the washes. So, leave the waxed graphite paper to the oil painters, and take the extra time to put your own graphite on the back. Simply take an ordinary #2 pencil, and, using the side of the point, shade the reverse side of your sketch using broad sweeping strokes over those areas you wish to transfer. Then re-draw or trace your sketch onto your support. Remember, the less erasing you do on the support, the less you alter the absorbancy factor of the surface. Rough or scuffed areas tend to absorb more color, creating darker areas or patches.

START WITH A GOOD DRAWING! This may sound silly, as it certainly goes without saying, or so one would think. Yet, you would be surprised at the number of paintings that are well executed but suffer from a poor drawing. The painting can only be as good as your drawing. Know your subject matter, learn the basics (perspective is the most common area of weakness I encounter in students), and be sure your drawing is correct before you paint it!

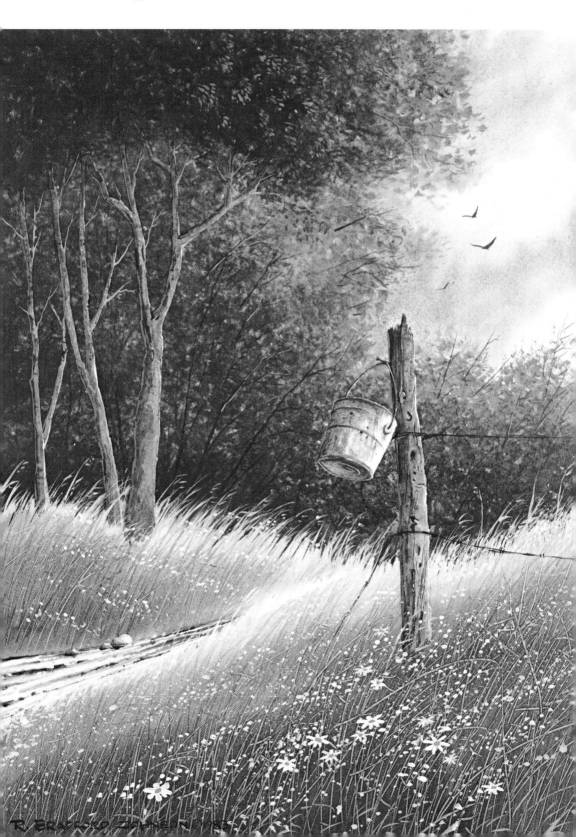

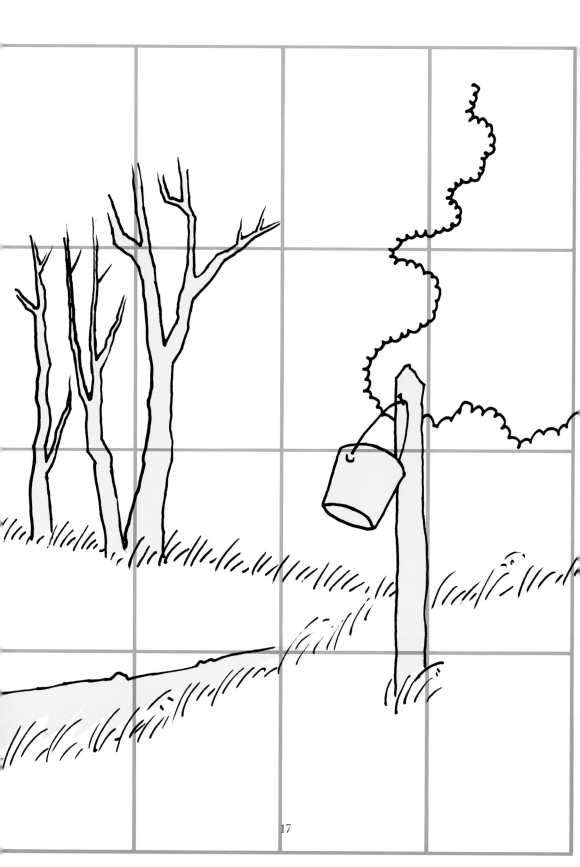

The Foliage

The color shown is Burnt Sienna to the left, and Phthalo Blue, with the Burnt Sienna in a little greater abundance, thinned with water. Your value and color should match circled area.

The tree foliage is stippled using the largest round brush (D on page 5). Study the pattern of light areas, noting the density is greatest in the center of the tree, and near the underside or bottom. Soften the edges, and keep the shape loose by using the brush with less quantities of paint near the perimeter (see techniques on page 8). Let the shape "grow" naturally; don't paint lollypops.

Stipple again, with a thinner, more translucent application of the same color (the value will lighten with the addition of more water). Keep the color consistent, controlling the value with the water. Do not attempt to paint too dark or opaque and expect to lighten the color with a lighter wash. It won't happen. The light areas of the foliage are the areas left white with the first stipple step.

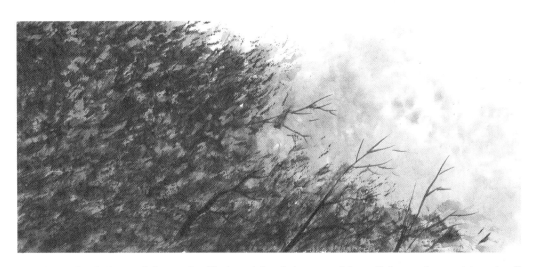

For the look of distant foliage, the *illusion* of depth is created by a lighter value and less detail. Stipple again as before with the lighter wash value, then quickly dab the moist color up with a wadded dry tissue. Work fast, as the paint will not lift once it has begun to dry. You can also use the Wet-into-Wet method here for additional softness, especially around the edges.

Branches can now be added using the fine brush and a mixture of equal parts Burnt Sienna and Mars Black thinned with water. Study the shape of these branches, on page 62.

THE GRASS

The color shown is Burnt Sienna to the left and Phthalo Blue to the right. Use extra parts of Burnt Sienna in this mix, thinned with plenty of water. Use the color and value circled.

UNDERPAINTING

Before you begin with the color above, mix a small amount of Yellow Ochre Light with Cadmium Yellow Light, approximately equal parts, and thin with water. Apply a wash of clean water to your support using your 1″ flat brush in the areas you plan to paint as grass. Now tint these areas with your yellow mixture with a gradual value change; darker at the bottom, and becoming lighter near the upper "ridge" areas of your grass. Allow this to dry (you may wish to keep a hand-held hair dryer within reach to accelerate drying between steps). This *underpainting* will give your painting a rich glow as if warmly lighted by the sun.

Apply a new wash of clean water to the now dry board, in the areas previously tinted yellow (I usually extend my water slightly beyond the actual grass area, to avoid a harsh line where wet meets dry). (A word of caution—be sure you have not left any "dry" spots when you apply your water. These will absorb color differently, dry faster, and thus create a patchy look.) Using your large round brush (D as shown on page 5), apply the color shown above, working in broad sweeping strokes, starting at the bottom and moving up. The value should gradually become lighter as it moves up toward the ridge. Add most of your color to the bottom, working it up into the water.

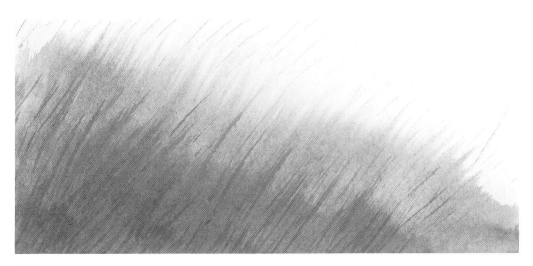

While the paint from the previous step is still wet, begin converting the horizontal strokes to vertical strokes using the fan brush. Brush in an upward manner, starting at the top of an area, and moving across and down in successive rows or steps. Work quickly, while the paint is still very wet. Each successive row should overlap the bottom of the stroke in the row above.

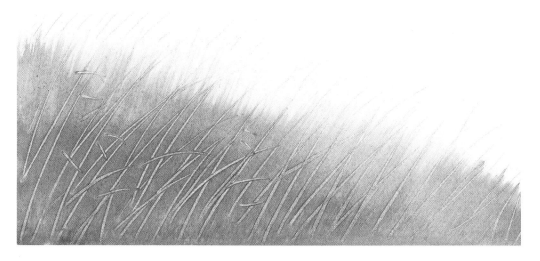

While the painting is still wet, begin scratching the surface of the painting where you wish the appearance of grass. Use shorter strokes near the top, longer at the bottom to create the illusion of depth. Move rapidly and use enough pressure to leave a mark. (An excellent scratching tool is the back end of a brush handle).

TREE TRUNKS & FENCE POSTS

The color shown above is a mixture of Burnt Sienna to the left, and Mars Black to the right. Mix approximately equal parts, then thin with water. Use plenty of water, test for value on an index card. You can control the tint with your proportions of paint.

For tree trunks and fence posts, you will want to create the illusion of grain. Some of this detail can be added later, but by the simple application of the paint in a directional manner consistant with the desired grain (a very wet solution), and immediate dabbing with a wadded tissue, much of the illusion can be created and suggested quickly, and often, more convincingly. The shape of the tree or post is also very important. Trees come in all shapes and varieties, and it is best to first find a tree that you like, appropriate for the painting, study it, and then draw it several times to fully understand the contours. It is a cylindrical shape, and must be modeled and shaded as such. If it's going to be a large area of the painting, break it down into areas so that you may retain control during painting.

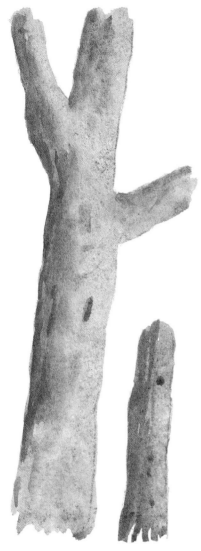

The fence post and tree are both wood and cylindrical, and as such can be painted in a similar manner. After brushing in the color, conforming to the shape and dabbing for texture, we can work in some additional color for a darker value on the shadowed side while the paint is still moist. As it begins to dry the lines will become more defined, and holes, actual grain patterns, and *drybrush* modeling can be done (for *drybrush* painting, simply use less paint in the brush, either by loading less, or by pulling some out with a tissue).

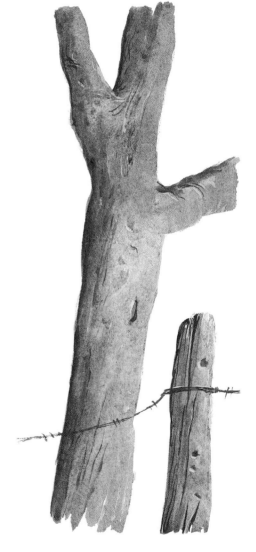

Using the smallest of your round sables, put in the final highlights and detail. For the highlights, use some opaque white tinted slightly with just a touch of Yellow Ochre Light, and the original base color shown above. A word of caution. Tint very gradually! The fine brush can be used to *spot* and *draw* accents for grain, holes, edges, and the barbed wire. For the wire color, use the above base color, but tinted with additional Burnt Sienna for the illusion of "rusty metal".

Highlights, Spatters & Flowers

The mixture shown above is Titanium White, and a mixture of equal parts Yellow Ochre Light and Cadmium Yellow Light used to tint the *opaque* white. Though most of the painting is done in translucent washes, the final detailing is done, quite often, with opaque mixtures.

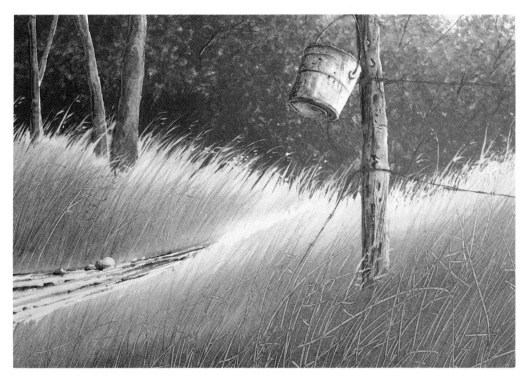

The ragged edge of the ridge, and additional fine detailing of grass and flowers, is done with the fine round sable and the color shown above. The paint should be thinned with just a little water, in contrast to the very wet washes we have used previously. Just enough water to help the paint flow off the brush, without thinning so much as to lose opacity. The stroke should travel upward, should vary in length and spacing, and have a slight curve to its nature. Note also that I have placed these very close together, often overlapping strokes. Too much space, and you will lose the illusion. Random length at random intervals will also look much more natural than symmetrical spacing and length.

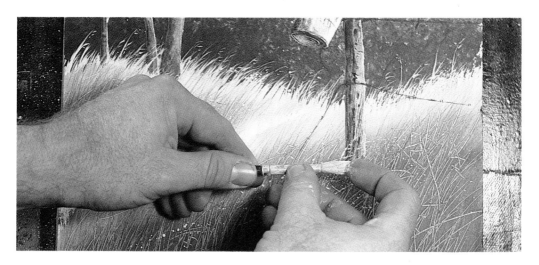

For the spatters, use the same color mixture, but thinned with additional water. I use my largest round sable for this technique, tickling the end of the brush, which is held horizontal on a parallel plane to the painting, about 5 or 6 inches away. Some artists prefer the toothbrush, or fan brush for this technique. Find the one that suits you best, and practice first on a scrap board...not on the painting. A word to the wise—a very wet mix is actually easier to control than paint that is too thick.

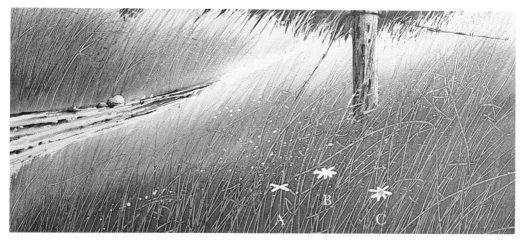

For the flowers, the color is the same as the first mix used for the ridge. With the small round sable, *draw* a flattened X (see above A). Now add two short strokes to the bottom, between the two legs of the X; follow this with one short petal stroke between the upper arms of the X (see B & C). With the same brush, dab a spot of Yellow Ochre Light onto the center of the petals. Note the pattern established in the over-all area. There is a flow, a movement, that carries the eye through the painting. Notice also that the horizontal contours of the land are accented by this flowing movement. The flowers and patterns can also be used to establish depth. Put larger flowers in the foreground, smaller in the distance.

THE SKY...CLOUDS

The colors shown are Phthalo Blue to the left, and Mars Black to the right. Note that the Black is used three parts to one part of the blue. Phthalo Blue is very intense, and should be used cautiously in larger proportions. Thin considerably with water.

For the sky area, first wet with clear water using the 1″ flat brush. Lay the support flat for this step, rather than at an angle. The water will "pool up" and not run when the board is flat, thus preventing accidental runs and drips. With the large round sable, loaded with a very wet mix of the color above, stroke and dab a dark cloud movement into the wet area. Note the above *pattern*. You may wish to practice patterns several times first. While the paint is still wet, blow on the sky area to soften the "cloud formations". You will have to exert some force to accomplish this step. After the sky has thoroughly dried, re-wet it again the same as before, and using a thinned mixture of Yellow Ochre Light and Cadmium Yellow Light (no white in this mix), tint a part of the sky to suggest a directional glow of warm sunlight.

SPECIAL NOTE: Some artists prefer to *reverse-out* a cloud formation. For this method, wet the sky area with clear water, paint in an even shade of blue-gray, and while the paint is still very wet, dab out the color here and there with a wadded tissue. Immediately spray a fine mist of water over this area, and blow the edges soft.

THE PATH

The path is done with the same color as was used for the post and tree trunk. With clear water, wet the path, overlapping both the top and bottom areas of grass. With brush B, apply a wet solution of the gray-brown mix in lines or horizontal strokes, dabbing here and there for rocks and pebbles. After this dries, use the color again on the dry surface to sharpen any edges and define lines.

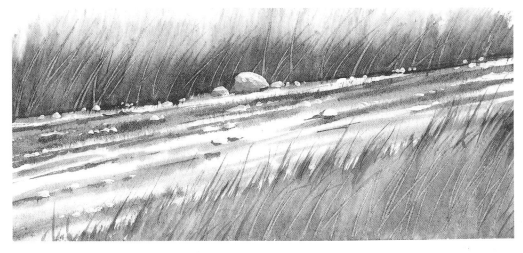

Using the light opaque mixture shown at the top of page 24, highlight the rocks and upper ridges of the ruts. A dab of thick opaque here and there will also create a nice highlight illusion.

Lesson #2 The Barn

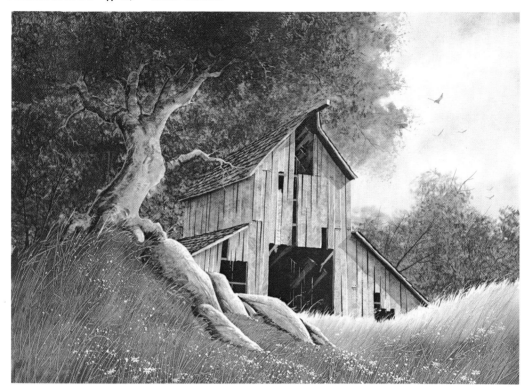

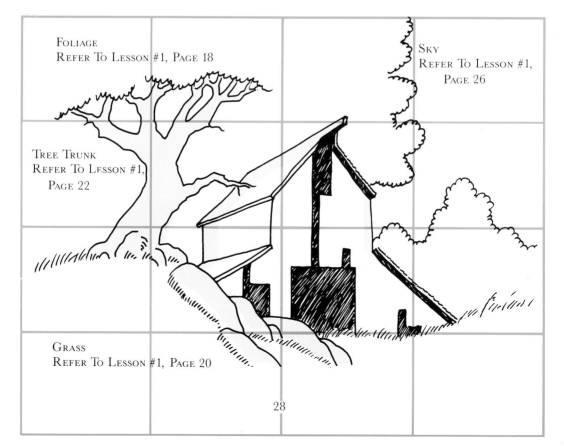

FOLIAGE
REFER TO LESSON #1, PAGE 18

SKY
REFER TO LESSON #1,
PAGE 26

TREE TRUNK
REFER TO LESSON #1,
PAGE 22

GRASS
REFER TO LESSON #1, PAGE 20

THE BARN ROOF

The colors shown above are Burnt Sienna to the left, and Mars Black to the right, with a ratio of two parts of the black to one part of Burnt Sienna, thinned with water.

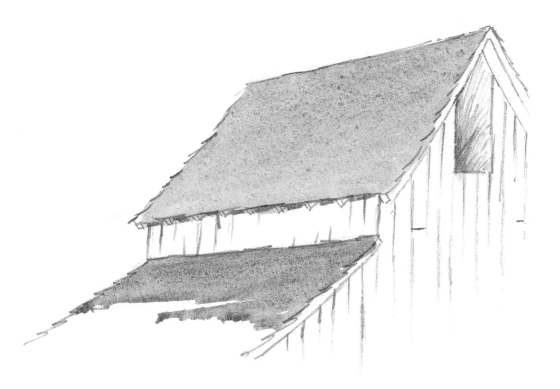

The barn roof is first layed in as a wash of the color and value shown above. Work one roof section at a time, starting at the top, and working the bead of paint across and down, letting gravity feed the downward flow. Do not attempt to outline the area, and then fill it in, as you will often get linear definition. Cut the edges to the sides as you work horizontally and down. Work rapidly so that the paint is still wet for the step to follow.

The paint must still be wet to achieve texture. With a wadded tissue, lightly dab or tap each roof area, carefully turning your tissue to a clean surface with each dab. Avoid dabbing with the same surface of the tissue, as you will often get less texture, and the possibility increases that you will pick up paint and transfer it to another area. For this technique refer to page 11.

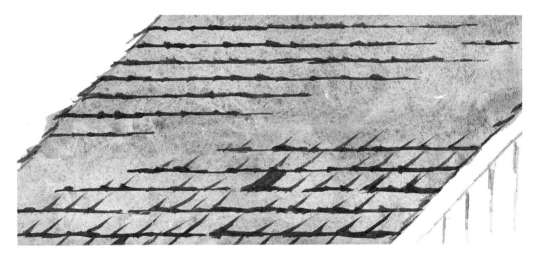

For the shingle pattern, use the same color, but a darker value (less water, more paint). The paint should still be wet enough to flow from your brush, but opaque for contrast. With the small round sable and your ruler, begin at the top of the roof area and work down, painting a series of ragged horizontal lines, no more than a ¼" apart. See the technique on page 10. Next, the angled lines are added, slanting these to the same angle as the roof slope. Do not make these too vertical, as the illusion will be destroyed.

THE SIDING

The color for the siding is the same as that used for the roof, shown on page 29. By varying the proportions of the two colors, one can create a full range of warm to cool gray-browns, and the values can be controlled easily with the amount of water used to thin the color.

Use brush B or C for the siding, depending on the finished size of your work (the width of the line should be relative to the size of the structure. For depth where there are multiple structures, or vanishing perspective, use the smaller brush for the distant lines, and the larger brush for those nearer). I find it is easier to turn my board on its side and work horizontally when using the brush and ruler technique, shown on page 10. The round brush can be turned into a flat by first dragging one side over the palette, then turning it 180° and repeating the procedure. Use the wet solution of color, and don't wipe too much off when flattening the brush. Work three or four boards at a time, and dab with the tissue immediately while the paint is still wet to create your texture and wood grain. A few boards can be put in with the drybrush technique for additional effect. I sometimes return to a board and repeat the step, for a slightly darker value here and there. Try repeating on only half the length of a board for additional variety.

The shadow lines are put in with the darker value once again, as were the shingle lines. Unlike the shingles, instead of a ragged line, use a smooth tapering line. Make the lines random in length and placement. I generally start at one end or the other and let the line fade out towards the center. Use your small round sable and the ruler, as shown on page 10.

Add your final texture and wood grain with the wash color and the small round sable. Select boards at random (using artistic judgement), and paint in fine lines to suggest wood grain, an occasional knot-hole, and even a nail head or board-butt. Create interest with texture. A small streak of Burnt Sienna to suggest rust flowing downward from a nail head can add that final spark.

SHADOW WASHES

The color shown above is Phthalo Blue to the left, and Mars Black to the right. As always with Phthalo Blue, a much smaller proportion of this color is used in the ratio. Three parts black to one part blue, thinned with water. Check color and value on a scrap board before using.

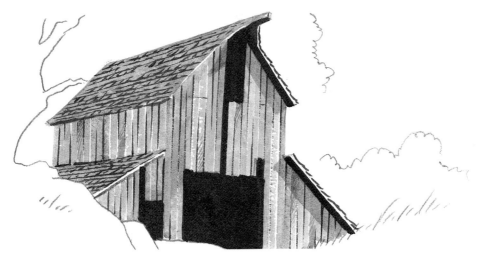

Cast shadows are first layed in with brush B, using the wash value of the color above. Apply a wash under the eaves and down into the face of the building, with a hard edge parallel to the roof edge to create the illusion of a cast shadow. You may wish to select an occasional board or crack to accent with a shadow. Doors will also cast shadows, so don't overlook any projection. And always remember that the shadows must appear to be cast away from the source of the light.

The blue-gray color can be used throughout the painting to shadow objects and structures. The trunk of the tree, the rocks, posts, boxes, wagons, etc. can all be shadowed to enhance the painting. But be consistant with your light source, your shadows, the color and value. And when working with cylindrical forms, use the Wet-into-Wet method to soften the transition from shadow to light.

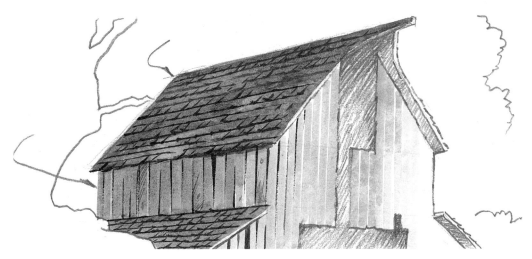

For the larger shadow areas, such as the roof and side of the barn, use brush C. Starting with the upper roof, and working down, apply a thin wash. Work across and down, an area at a time. Once again, try *not* to outline and then fill in. Use the tissue to dab if the value appears too dark. Don't be afraid to use plenty of water in your wash. It is easier to repeat a light value as a second wash in order to darken the value than to try and lighten it once it is down. And once it is dry, it is there permanently.

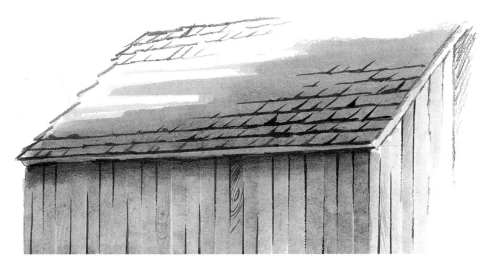

Adding depth to the shadows in and under the eaves will add a final touch to the structure. To create this illusion, we will work Wet-into-Wet for a soft transition in value. With clear water, brush a line (about an inch wide) immediately adjoining the underside of the eaves, then with brush B, work some of the darker value of the color above directly under the eaves allowing the water to soften the lower edge of color. A final word of caution: check your color prior to use—don't let the blue get away from you.

ROCKS

The color shown above is Burnt Sienna to the left, and Mars Black to the right. Mix three parts of the Mars Black to one part of the Burnt Sienna, and thin with water.

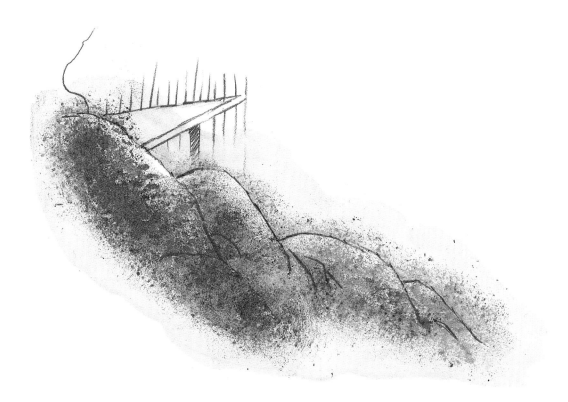

Although there are several ways of painting rocks, we are going to introduce the sponge method in this lesson. Begin by brushing a frisket outline around the rocks, to protect our grassy areas. Then, using the sponge dipped into a wet solution of the above color, dab texture over the entire rock formation.

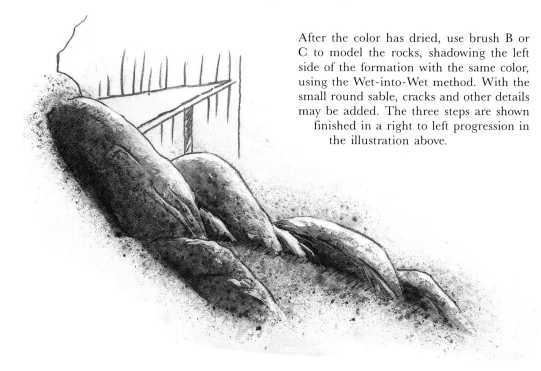

After the color has dried, use brush B or C to model the rocks, shadowing the left side of the formation with the same color, using the Wet-into-Wet method. With the small round sable, cracks and other details may be added. The three steps are shown finished in a right to left progression in the illustration above.

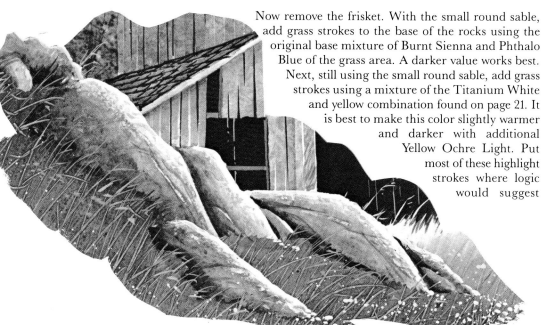

Now remove the frisket. With the small round sable, add grass strokes to the base of the rocks using the original base mixture of Burnt Sienna and Phthalo Blue of the grass area. A darker value works best. Next, still using the small round sable, add grass strokes using a mixture of the Titanium White and yellow combination found on page 21. It is best to make this color slightly warmer and darker with additional Yellow Ochre Light. Put most of these highlight strokes where logic would suggest the sun would catch and light them. Don't put the light strokes in the deepest shadows. Finally, using the same small round sable and the light opaque color, highlight the rocks and cracks as shown above.

LESSON #3-A WINTER LANDSCAPE

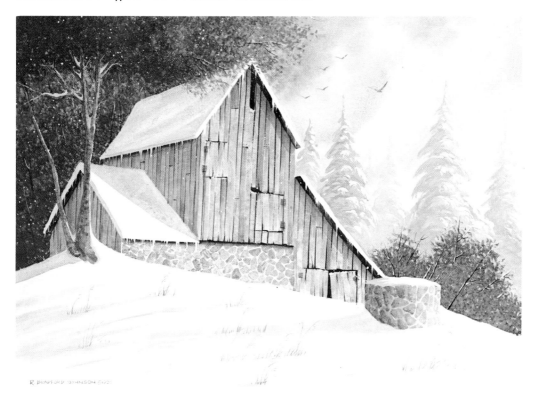

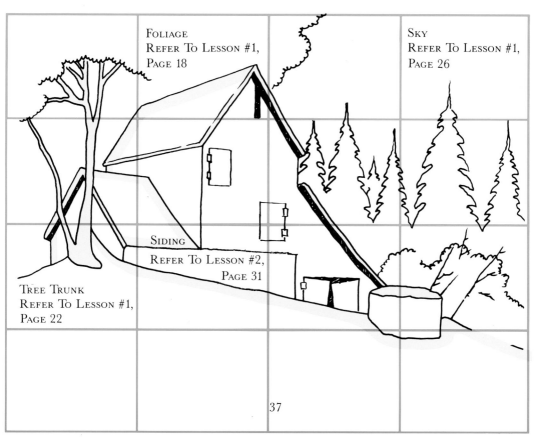

FOLIAGE
REFER TO LESSON #1,
PAGE 18

SKY
REFER TO LESSON #1,
PAGE 26

SIDING
REFER TO LESSON #2,
PAGE 31

TREE TRUNK
REFER TO LESSON #1,
PAGE 22

STONEWORK

The color used for the stonework is the same as the roof mixture shown on page 29.

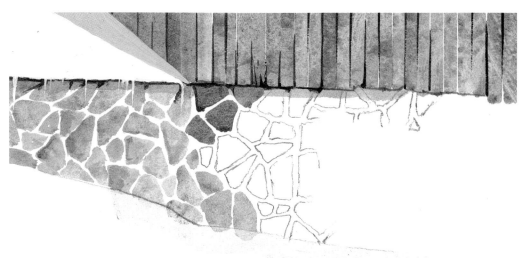

For stonework on a flat surface, such as the foundation of the barn structure shown above, use brush B, and lay in a series of interlocking triangular shapes, moving from one side to the other. Don't attempt to make the shapes perfect triangles. Work instead with varied, non-symmetrical shapes. Change the value here and there, and don't be too consistent with size. Make some stones smaller, and others larger than the average. Use common sense to determine the relative size of the stones in your foundation as well as in other situations, such as the well. An occasional dark line on the underside of a stone, or just under the edge of the overlapping wood siding, will add contrast and interest.

The well is done much the same as a flat surface, but with one major difference. The stones change shape, since this well is a cylindrical form. As the stones near the curved edge, left and right, they become thin vertical shapes, creating the illusion that they are receding around the sides. It also adds to the illusion to darken the stonework on the shadow side. As with the siding, texture can be created by using the wadded tissue to dab the wet stones. Do no more than four or five at a time, and keep the solution very wet. Turn the tissue periodically to keep a clean surface in use at all time.

Snow-Capped Pine Trees

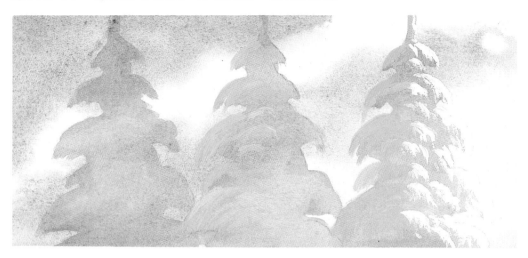

For the Pine trees, we will begin with a wash, using the light blue sky color shown on page 26, tinted slightly with Burnt Sienna (use caution—a mere suggestion of green is the goal). Begin at the top of the tree form, working down, filling in the shape as a flat area. Where trees merge with one another, it is best to paint one tree at a time, working each tree into a wet edge where another tree adjoins. Allow to dry, then wet the adjoining edge, bring your new tree down, and merge. Allow to dry. For the next step, mix white with the sky mixture (the thinned color shown on page 26), and paint the shadow side of the branches with a light value of opaque blue-gray color. The strokes should suggest rounded mounds of snow clinging to sagging branches, and are carried on into the center of the tree as shown. White is then used to highlight the snow on the sunlit branches.

Use the same two opaques for the icicles; the light blue-gray color in the shadowed areas, the white in the sunlight. (Note: when doing the icicles, vary the length and spacing.) The snow spatters are also white, thinned with water (use the technique shown on page 25). For the roof and foreground areas in shadow, tint slightly with the sky color (page 26) as shown, utilizing the natural white board for much of the sunlit areas. (In these areas, the blue-gray has *no* white added.) Keep the value light. Use brush D for the large broad strokes. It may be advisable to wet many of the large areas first to increase control.

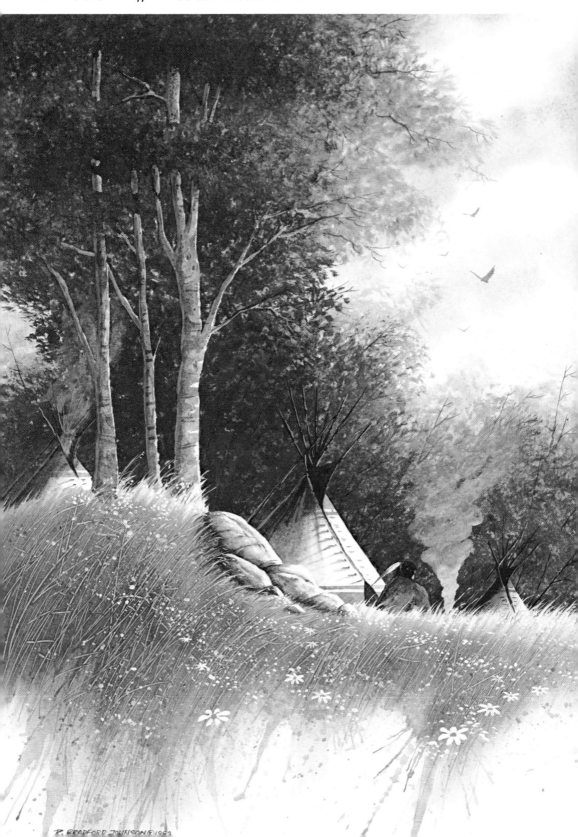

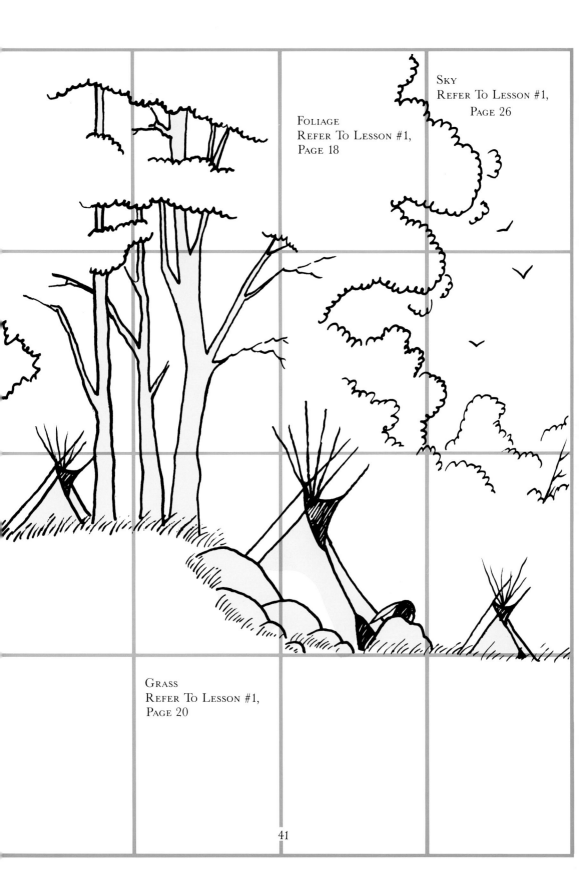

FOLIAGE
REFER TO LESSON #1,
PAGE 18

SKY
REFER TO LESSON #1,
PAGE 26

GRASS
REFER TO LESSON #1,
PAGE 20

The Teepee

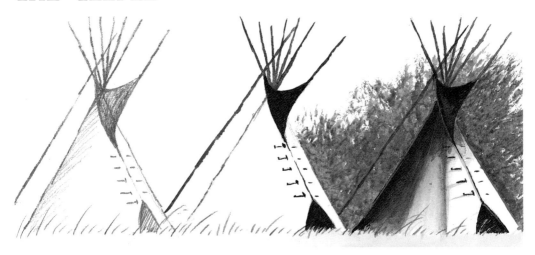

For the Teepees shown above, we mix basically the same colors as we used for the barn roof, (see page 29) using a darker value to fill in the darker areas (less water for the darker value) such as the smoke-top and entry. Since the shape of the teepee is conical, we can approach it somewhat the same as with the cylindrical shapes we have already painted. Use clear water to wet the sunlit side of the teepee. Then, as with the tree trunk, put a darker value wash along the shadow side, and continue to work it around and into the water so that the value grows even lighter and the edge fades. If you wish the support poles to show some light and shadow, break the teepees surface into areas and reverse the shadow procedure. It is always best to allow each stage to dry thoroughly before attempting to add more water or color to an area. The dark color can then be used to detail the poles, the flap, stakes, etc.

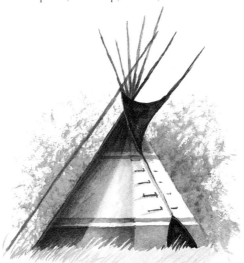

You may wish to decorate your teepee. Shown above is a simple pattern. Note that the lines are horizontal and straight. They *DO NOT* curve up or down to create an illusion of roundness. (Since the teepees are on the horizon line in this painting, the decorative lines will also appear at eye level and visually flat or straight.) Try using a variety of other colors for this and other similar designs on your teepees. Or, study some authentic Indian symbols, and transcribe these to your teepees.

THE SEATED FIGURE

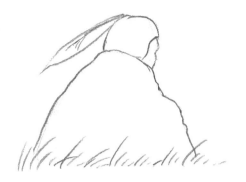

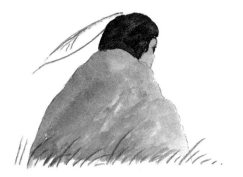

The drawing above is very simple. A seated figure before the campfire. Use this drawing to make a tracing (which can also be reversed for figures facing the other direction). Transfer the figure to your picture. Be sure the drawing above is scaled in proportion to your painting.

With a mixture of 3 parts Burnt Sienna and 1 part Mars Black, fill in the blanket or shawl draped over the shoulders. Use Mars Black to then fill in the hair area. The face can be done with a light wash of Burnt Sienna (thinned with water!).

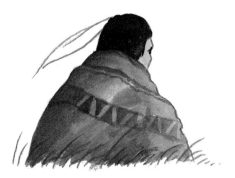

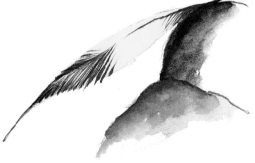

After the base colors of the form have dried, wet the blanket area with clear water, and model some shape to the form with Mars Black to the shadow side. While the figure is still wet, add a few appropriate folds to the blanket. You might even wish to add highlights, or a pattern to the blanket.

The feather is now added. Fill in the shape with Cadmium Yellow Light. With your finest round sable, add the red area as a series of lines (use your Cadmium Red Medium), then follow with Mars Black and a few lines as shown above.

CAMPFIRE SMOKE

Smoke rising out of the campfire, or for that matter, a chimney of a rural farmhouse, can add life and charm to a painting. But a word of caution! It can also become a bit gimmicky if over done, or done badly. Study the smoke in the original painting. Notice how it dissapates as it swirls skyward. Now to create this illusion, begin with Titanium White. Add water and ever so small a touch of the sky gray-blue (see page 26). Use brush B. Start at the ground level or horizon, as the case may be. Place the tip of the brush at the point of origin and begin to sketch swirling loops, overlapping these, one above the other, as you move upward. Don't be too symmetrical. Allow the loops to grow slightly larger one above the other.

Midway up, touch the tip of your brush to clear water, and resume your swirling loops. The paint should begin to fade, and the color disappear, until finally your "smoke will have dissapated." Practice painting smoke several times on scrap board prior to attempting it on your painting. Most common problem: not enough water in the mixture.

LESSON #5-BARN WITH WINDMILL

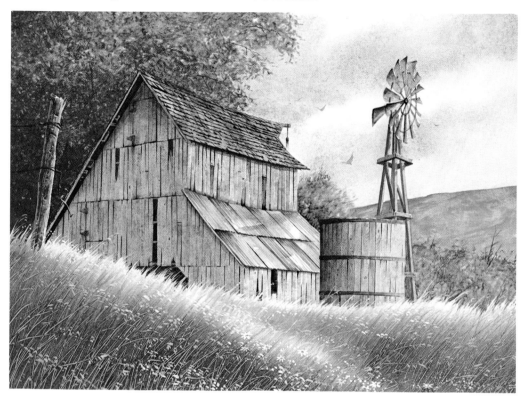

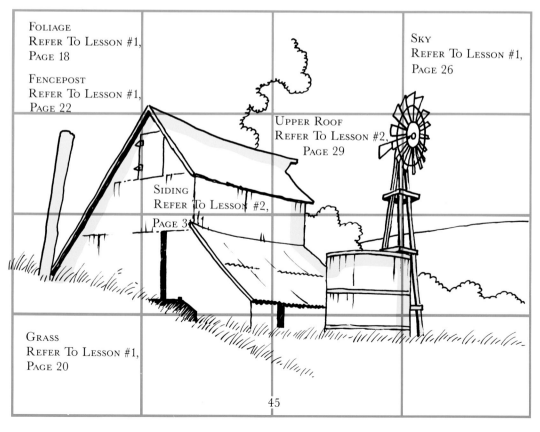

FOLIAGE
REFER TO LESSON #1,
PAGE 18

FENCEPOST
REFER TO LESSON #1,
PAGE 22

SKY
REFER TO LESSON #1,
PAGE 26

UPPER ROOF
REFER TO LESSON #2,
PAGE 29

SIDING
REFER TO LESSON #2,
PAGE 3?

GRASS
REFER TO LESSON #1,
PAGE 20

THE TIN ROOF

The color to be used for the tin roof is the same as for the sky (see page 26). Rust may be added Burnt Sienna thinned with water, tinted slightly with Mars Black.

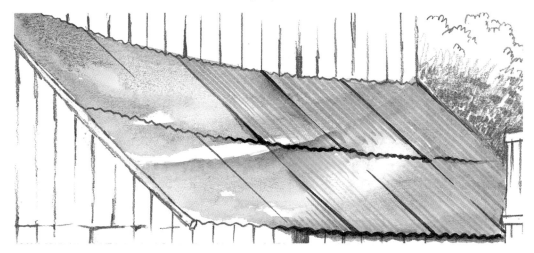

Note first that the edge of the roof is drawn with a wavy line to create the illusion of corrugated metal. With your large round sable (brush D), brush two or three strokes of clear water horizontally across the roof area. Don't try to fill in the entire roof area. Now, load the same brush with color, and repeat the previous step, adding a few additional strokes, filling in one or two of the corners, and sharpening up a side or two. Allow to dry. Switch to the small round sable (brush A), and, using the ruler, add thin lines with the same color, keeping these lines angled to the roof slant, or side edges. A dark value of this color can now be used to shadow the undersides of the overlapping panels of corrugated roofing. Remember to follow the wavy line on the bottom edges, while keeping the line straight on the sides.

After the previous steps have dried, take some Burnt Sienna, thin with water, and tint ever so slightly with a little Mars Black. With the small round sable (brush B), paint over some of the blue-gray lines, working an area, and starting at either the top or bottom edge of the roof panel. Don't go overboard. The illusion looks best when done as patches and not scattered randomly throughout.

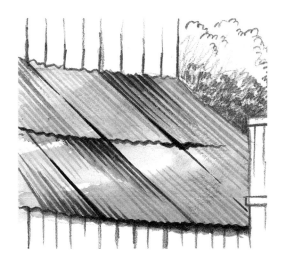

The Water Tank

The color for the water tank is the same as the wood siding shown on page 31. Brush some frisket over the metal rails on the tank.

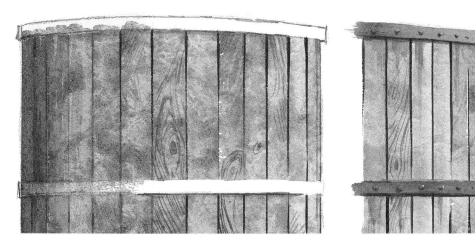

The water tank is nothing more than a simple cylinder, much like the stone well in Lesson #3. We will create the illusion in much the same manner. The boards near the center will appear wider, and diminish in width as they move left and right around the sides. Using the ruler technique and Brush B (remember, it is easier to work horizontally, so turn your picture on its side) paint your boards in with the siding color, using a slightly darker value on the shadow side. With the small round sable and a darker value of the same color, paint in the darker lines or cracks. Upon drying, remove the frisket and put a wash of Burnt Sienna over the rail areas. Shadow with a dark line to the bottom side. A few rust stains may now be added, suggesting a downward streaking.

For the shadows, we once again return to our blue-gray mixture (see page 26), and in much the same manner as we did the well, we will shadow the water tank. Wet the right or sunny side with clear water (at least half the tank on one side). Now work the blue-gray across the surface until it meets the water and allow the edge to soften. Allow to Dry. A second wash may again be brushed over a few boards to the extreme left edge for deeper shadows.

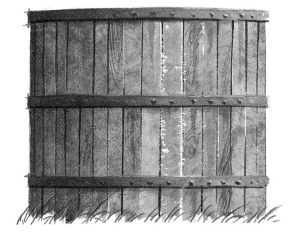

THE WINDMILL

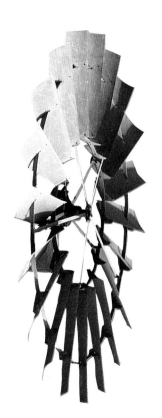

The Windmill is one of the most difficult illusions to create. It must begin with a good drawing. I would suggest finding a good windmill and photographing it from various angles, and in different lighting. If you are unable to find your own, go to the library and find some pictures in books. Study the shape. Sketch it. Understand it. For now, the windmill on this page will be sufficient for this lesson.

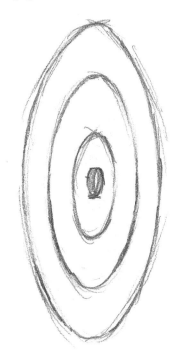

Begin with the elipses shown to the left. Try to duplicate the spacing as shown.

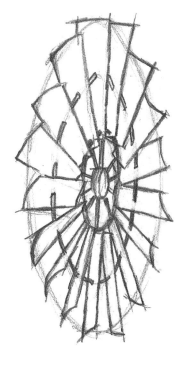

Now begin to add the blades. Notice how the shape and width of the blades changes as you move around the windmill. Use the outer most elipse as a guide for the outside edge of the blade, and the inside elipse for the inside edge. The center elipse, with parts removed, will serve as a support ring (see the photo illustration.)

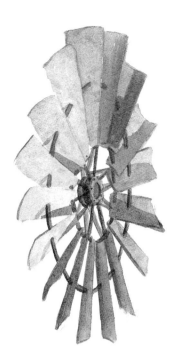

With the blue-gray sky wash (see page 26) begin to fill in the blades as shown. Some areas will receive a deeper value, but approach this as a second step, and allow the first to dry.

Now you can add the rust with Burnt Sienna. Do not cover the entire blade, but use the rust as an accent here and there. Deep shadows and highlights can then be added if desired. The paddle and superstructure can be seen on page 45. Study these, but be aware that there are many varieties of both, and the paddle itself can be found in two positions. When folded-in, the windmill is locked and not in service.

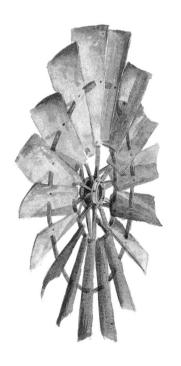

LESSON #6-THE UTILITY BUILDING

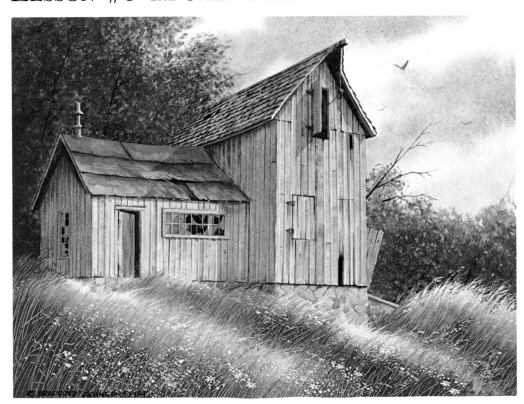

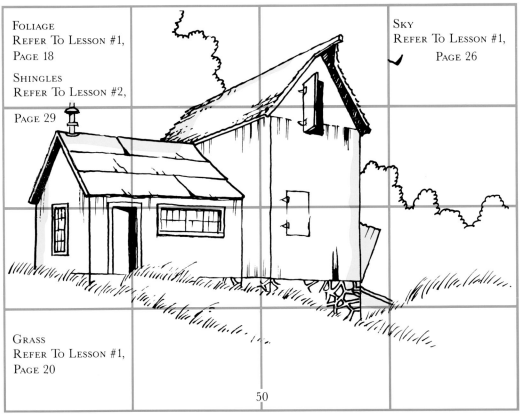

FOLIAGE
REFER TO LESSON #1,
PAGE 18

SHINGLES
REFER TO LESSON #2,

PAGE 29

SKY
REFER TO LESSON #1,
PAGE 26

GRASS
REFER TO LESSON #1,
PAGE 20

Rolled Roofing

The colors shown above are Burnt Sienna to the left, Cadmium Red Medium in the center, and Mars Black on the right. Use 3 parts of the Burnt Sienna, 2 parts of the Cadmium Red Medium, and 1 part of the Mars Black, and thin with water.

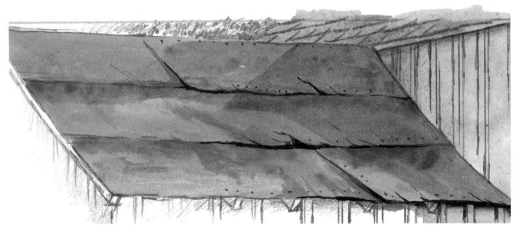

The roofing can be other colors, but the red shown above, and several shades of green, are the most common rolled-roofing colors found in rural areas. Begin with a wash, either filling in the entire roof, or a section at at time. Remember to move from top to bottom in horizontal brush strokes. Do not attempt to outline an area, and then fill it in. After this has dried, begin to fill in the dark accents of your drawing with a darker value of the same color. Add the cracks, nails, streaks, etc. Shown below is a sample of the same drawing, but in a popular green color. Shown lower left is the color sample. Mix 2 parts Burnt Sienna, 2 parts Yellow Ochre Light, and 1 part Phthalo Blue.

BOARD & BATTEN

The color for the Board and Batten siding is the same as shown on page 31.

Use the same colors and techniques for the Board and Batten siding shown above as for your other siding, with one big difference. Space your boards a little distance apart. Approximately ¼ the width of the board. Allow to dry, then overlap a second stroke for the Batten, leaving a small gap to the sunlit side to act as a highlight. Use two

different size brushes for both the Board and Batten, appropriate to the scale of your painting. Remember, the board used in siding is generally 12″ wide, and the illusion you create should suggest this. A few dark accents with your smallest sable will complete the illusion.

THE WINDOW

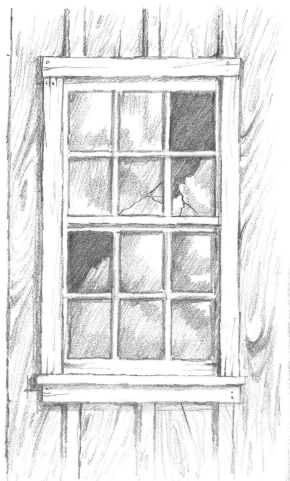

Shown to the left is the basic drawing for the window. You can paint windows many shapes and sizes. Shown here is the vertical window to the left side of the building. The rules for this window will also apply to the horizontal window in the front.

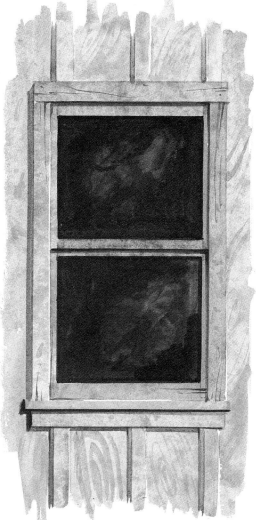

Fill in the entire window area with a mixture of 1 part Burnt Sienna and 2 parts Mars Black. Thin with water, but not so thin as to lighten the value to translucency. Note, however, the value is not completely solid. Leave lighter variations throughout.

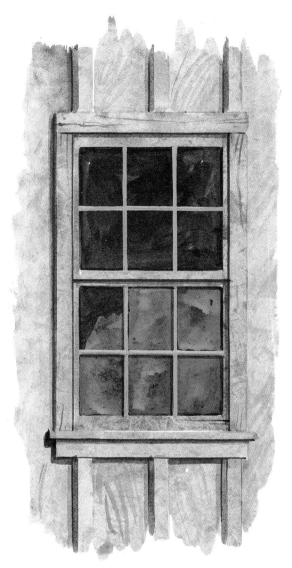

Although some artists prefer to first paint the frame structure with frisket, I prefer to come back with an opaque. Add Titanium White to the dark base color, until you have a value that approximates the surrounding wood tones. For windows in sunlight, tint your color with Yellow Ochre Light, and for those in shadow, tint with Phthalo Blue (use caution when tinting with the Phthalo Blue). Use your smallest sable and the ruler technique to put in the pane structure.

Now, with a thinned mixture of white and the blue-gray sky color (see page 26), fill in all or some of panes to create the illusion of reflective glass. A word of caution. Keep your paint thin, not too opaque. You can always add additional washes if the first fades away. For the final touch, add a shadow line under and to one side of the pane's frame. The blue-gray and your fine sable will work best here. The areas left unpainted now appear to be missing or broken window panes.

Lesson #7 - The Victorian Farmhouse

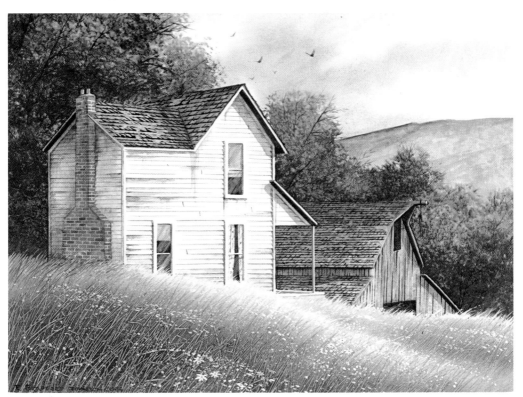

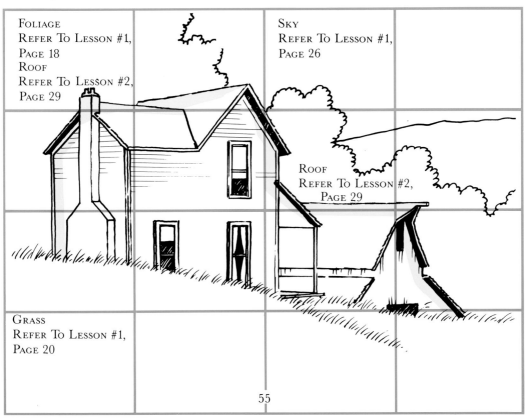

Foliage
Refer To Lesson #1,
Page 18
Roof
Refer To Lesson #2,
Page 29

Sky
Refer To Lesson #1,
Page 26

Roof
Refer To Lesson #2,
Page 29

Grass
Refer To Lesson #1,
Page 20

CLAPBOARD

For the white-washed structures, such as the farm house in this lesson, we will use the white of the support as the base color. Only shadows and detail need be added. Structures of other colors can be approached with the same rules and techniques as those that follow, but a wash to tint the white the appropriate color must be painted over the structure first.

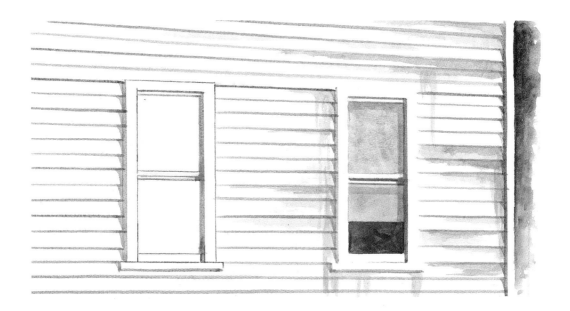

Be sure that all windows, door frames, and wood trim are first drawn in lightly with pencil. Using the blue-gray sky color (see page 26), and your smallest round sable, paint in the shadow lines on one side and on the underside of windows, shelves, doors, etc. Use logic to determine which side is the shadowed side. *Do not* frame in all four sides. Doors and windows will also have shadows on the insides of the framework, generally on the opposite side of the opening. In other words, when lighted from the right, the left side of the outer frame would receive a shadow, while the inside of the doorway would be shadowed on the right side, and on the underside of the overhead framing. The clapboard is then shadowed, using care to stop your lines at the shadowed edges, *and* at the pencil lines on the lighted side of your windows, doors, etc. When you have completed all of your shadows, the pencil lines can be erased (use your rubber cement pick-up) to create the illusion of a highlighted hard edge.

BRICKS

For the color of the bricks, see the mixture shown on page 51 for Rolled Roofing.

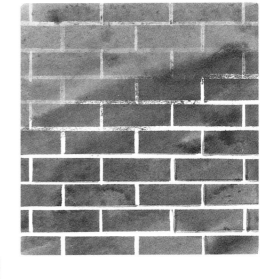

The bricks for the fireplace can be suggested with three different methods. The first method is to use the frisket for the mortar, painting in a neat pattern first. After the frisket has dried, a wash of the brick color can then be brushed over the top. After the wash dries, several bricks can be repainted a slightly darker value. When dry, the frisket is removed, and a brick pattern remains.

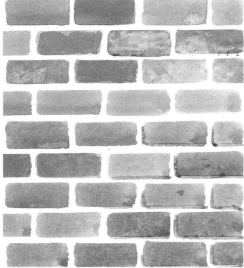

The second method is to simply paint in each brick individually, leaving the space for the mortar as you paint. As in all three methods, shadows, highlights, streaks, and other irregularities can be added for richer character.

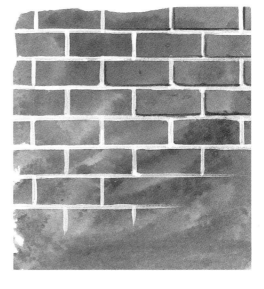

The final method is to paint the brick area in solid with your wash. The mortar is then painted as an opaque over the top. All three methods work well and will create the same general illusion. Try all three, then choose the method that appeals to you most.

CURTAINED WINDOW

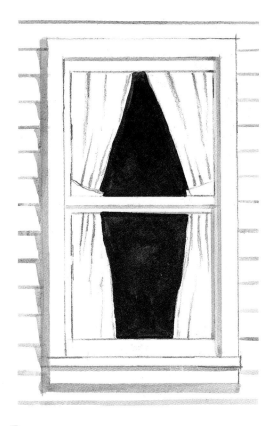

The curtained window is done very much like the window shown on page 53 and 54. Instead of painting the entire window with the dark value, only the area between the curtains is filled in, as shown.

Now the curtains are decorated. You may choose to use flowers, or possibly a favorite pattern of your own. Note that the curved surface of the curtains must reflect the same in your pattern. A few shadows in the folds can be painted with the blue-gray sky color. Shadows cast by the window's frame can also be added with the blue-gray color. Add a little white to this color, thin with water, and a few diagonal strokes (as shown on the bottom pane) will contribute to the illusion of glass.

WINDOW WITH SHADE

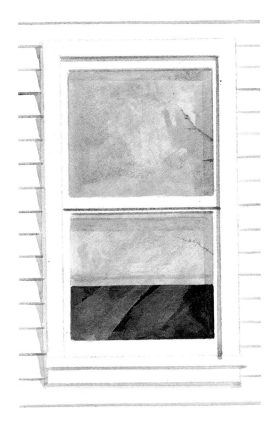

The window shade is another nice touch to add to windows. But be sure logic would allow curtains and shades in the windows of your structures. (Barn windows would not be a good logical choice for curtains!) Once again, use the dark value to fill in the window area below the shade. The shade, incidently, can be opened to any of a number of levels. Here it is drawn three quarters. The shade can be tinted with the same color and value as the woodtone used in the siding.

Using the blue-gray sky wash, appropriate shadows can be added to enhance the illusion of the window's frame. And, with the white added to the sky wash (thinned with water) the diagonal strokes can be added once again to suggest glass.

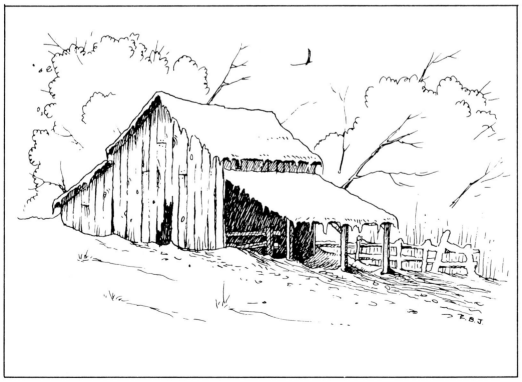

61

EMBELLISHMENTS

Many paintings suffer from lack of interest, some from inaccuracies, and others from a lack of life. I add birds, fine details, and an assortment of other equipment and embellishments to turn flat, lifeless areas of my painting, into little areas of activity and interest. Shown on the following 2 pages are some of the little embellishments used throughout this book, that may aid you in putting a little punch into your own paintings. These are merely examples, and you are encouraged to seek out other variations and subjects to explore on your own. Since the drawing is all important, in many cases it has been left intact and only partially completed as a painting. But by using the techniques explained earlier, thoroughout this book, you can complete these with little difficulty.

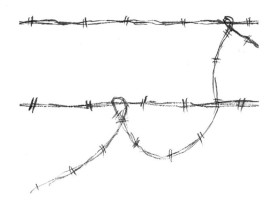

BARBED WIRE—Use the same color, or add additional Burnt Sienna if rusty wire is desired. With your smallest round sable (brush A), *sketch* the wire as two intertwining lines. Embellish with barbs, short vertical strokes in pairs, spaced as shown above. The wire can also be highlighted by adding Titanium White to Burnt Sienna, but shows up best against darker background.

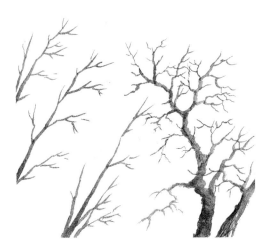

BRANCHES—Shown above are the most common branch formations. Note that both are formed as V's upon V's, each extension slightly reduced in size. For oaks, the twisty, gnarled branches can set moods of foreboding mystery, while the crisp angles of the evergreen can peek through foliage here and there to merely add texture and interest to what might be a flat and lifeless area. Study and practice these and other branch formations for your paintings. Use your smallest round sable (brush A) for fine branches, and brush B for larger. Refer to page 22 for the color mix.

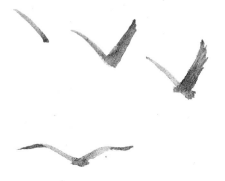

BIRDS—Use the color mix shown on the top of page 29 in a light value. The basic shape of the bird is made in two simple strokes. A simple pull stroke with very little curve, followed by a push stroke, upward, using the side of the brush. Depending on relative proportions, use either brush A or B. A short stroke at the base of the V can be added if a body is desired, but often the suggestion of the wings is sufficient to create the illusion of a bird. Note that most birds of prey look better if the wing is shaped concave, and seagulls if the wing is convex, and darkened at the tips. Feathers can be added if desired, but don't go overboard.